www.trafford.com

North America & international
toll-free: 1 888 232 4444 (USA & Canada)
phone: 250 383 6864 • fax: 812 355 4082

Favourite 80s Memory: May 16, 1983
Favourite 90s Memory: June 5, 1991
Favourite 2000s Memory: November 4, 2008

Favourite Spot On God's Good Green Earth:
Tate Modern (Rothko Room) in the UK.

Favourite Dream:
I'll eventually buy and create 365 t-shirts and
move somewhere super warm,
Sunshine everyday and wear one t-shirt a day,
no repeats, no regrets. So Necessary.

Favourite Christmas Movie:
Die Hard. ("Ho, ho, ho…")

Favourite Tradition:
Once a year every year I chill in New York City.
The art, the people, the culture, the ideas:
great town!

Favourite Cigar:
Romeo y Julieta. Cubans, son.

Favourite Smell:
Hot takeout in the car!

Favourite Poets:
Keats, Morrison, Frost, Bono, Angelou,
Springsteen.

Favourite Tea:
English Breakfast
(spot of milk, a bit o'sugar, thanks).

Favourite Word:
Magnanimous. I never use it but there it be.
Shucks rocks too. This I drop repeatedly with
the passion of a drunk sailor.

Photography by Jigar Talati

Sammy Younan
yo@sammyyounan.com

www.sammyyounan.com
www.supcuz.biz

RED LETTER NIGHTS

sammy younan

I'm interested in a lot of primitive symbolism that's almost biblical.
Some people choose turquoise.
I like red.
Bono
Spin magazine, June 01, 1987

To my family:

Thank you for your grace and your patience: I know I wasn't always present. I live a lot in my head; well now you get to see some of what I see.

Seeing Red...

I want to do for Red what Prince did for purple and Cash did for black.

Adopt, renovate, champion and herald.

The more tea I made; the more I pondered Red the more I grew to realize it's important to us as a society and as a (popular) culture.

From fire trucks to stop signs to companies to comic book superheroes it's *our colour*. (Start to name companies who feature red in their colours/logos and you'll still be here when I leave my office to go to Olive Garden for dinner.)

We may not be in a gang; we don't always wear it but it's *our colour*.

What does that says about us?

Why Red and not purple or green? Why did we choose to burden Red with so many connotations, meanings and beliefs? Red is our ongoing construction project we continually add to it, build on it; never leaving it be.

What does that says about us?

• • •

If that's truth this is dare.

Once you see something it's hard to "unsee" it.

Dare you—no! double dare you—to put this book down and not see Red everywhere.

This is how I lived for a few years writing these poems.

Like the Sun I don't understand everything Red does.

Like the moon I came to appreciate Red's unique beauty.

Like the stars I take comfort from Red's continual presence.

Seeing is believing.

• • •

A casual survey of music reveals consistent colour themes:

Jay-Z and Metallica have Black albums.

Beatles have a White one.

Weezer does have a Red album but well, sorry folks, it's not their best.

I'll take the Green or the Blue albums.

Music woos the colour spectrum. Poetry is no different.

Passion always makes the same sound.

What colour is your passion?

● ● ●

Suggested So Necessary Elements For The Deep Enjoyment Of These Poems:

(1) Comfortable chair or a warm bed. mmmmm.

(2) Tea. You're welcome to a beverage of your choice, of course Gentle Reader; it's just that tea works. Tea always works.

(3) Open Mind. Engage the works let Red's beauty unfold naturally. www.sammyyounan.com is there for you when you're ready to discuss debate and enjoy the discourse.

If you like, music is always a good accompaniment. As you like.

● ● ●

Thank you for purchasing this book. Thank you for taking the time to read it. I recognize your time is valuable. Hopefully what you discover within will be rewarding.

Oh and remember the goal of smoking a fine cigar is cool smoke so be sure the cigar never touches the flame to achieve a good light.

Sammy Younan
September 28, 2009
Scarborough

Track Listing

Track Listing

Red Tape
Much papers slow time
Rigid rules embitter souls
You promised reform

Red Light District (for Roxanne)
Such sweet sin free guilt
Caged heat pent up countless nos
Close enough to love

Caught Red Handed
The Home Life is hard
Lights entice must always leave
Stop running be slow

Red Letter Day
Sunset caps good day
Special day of healing faith
Eternal night of fresh hopes

The Dance

I took her form in my arms.
Having no forethought, she began
her act of discreet disclosure.
She became my fantasy:
I could feel the sharp sweet sting of her pull—
her allure a double-edged sword
heavy like her musk.
In the dark red of the heat,
the swaying of the musical beats
twin hearts throb with want
and destroyed by need.
Our strategies and tactics
melt with the coming of our warm skin.
a prophecy of black:
a death foretold,
an end all too near.
Purity erodes.
Urgency hastens.
Her caress the lingering spark of desire.
Our lips brush:
unspoken twisted fates among
our thighs embroiled in a tug of war:
a strange checkmate climax.
Her hunger wanting,
My passion exploding,
blinding,
tearing down:
empty.
There is a seize,
a siege,
a dream realized,
an end
a fade: the music and them.

.-. . -..- -

She comes into my life with high expectations.
I know little about her, just that
she tastes good.
She never demands from me, knowing her limits.
It satisfies her to satisfy me.
Her murky black depths I've never fathomed,
her past full of unknowns, flukes and half-truths—
there was the rumour of her using drugs
She's clean now but still, I wonder: fact or fiction?
Her origins are clouded like rainy days,
her family is a Robert Stack unsolved mystery.
Thinking of her makes me want her…again.
I gaze at her: her slick skin reflects the Sun's rays.
The invitation I receive, the duty I perform:
I reach into my cooler for yet another can of Coke.

-.-. --- -.- .

Metaphors

I surround myself with metaphors
lest I forget
and grow comfortable in the warm doze of my freedom.
For the pale pink flowers must
remind that all born will soon perish:
beauty, while awesome, is fleeting.
I envy their ability to grow while I
(a somewhat reasonable innocent man)
remain arrested
in a childlike state of intelligence.
So I keep the clothes and toys of youth
sad pathetic yellowed indications
of how much I have aged but not grown—
I fail more than I try:

Success is a horizon bridged only by an unruly sea of doubt.
So I keep this cup of water by my bedside.
Together: the water and I evaporate;
every morning is a struggle to find an adequate measure of hope—
to somehow cherish it and let
the small warm embers flourish, perhaps
ignite into a blaze able to sustain the long desperate sentence of life.
But every night I go to bed and see how the water level sinks
grows small and with horror I can see my time here is fleeting.
Like a metaphor birthed fresh into a tea-conversation
a sudden quick illumination in a heavy discussion
it eventually slides into cliché
overused
eventually abandoned
like myself
tired and sad, hard pressed, I no longer remain *distinct:*
(I have become ordinary)
my greatest crime is accepting this verdict is true.
No longer able to claw forward towards what I thought was a destiny laden
with greatness
I'm just a human being
A Face In The Crowd:
my mirror never lies
now my entire daily activity is to fence myself in with books
as I await the final chapter.

Perhaps there will be an epilogue after death
A heaven to erase the suffering of this state
A new joy and a gift; not an old happy.
So I keep this cross handy while I wait.

••–• •–•• –—— •–— • •–• •••

Red Shirt Lamentations

The noble sacrifice of the foolish
The proud strike of the stupid
The rough and ready reality of the rash:
Fools modelling risk.
Risk is robbed if it does not yield applicable knowledge.
Easily expendable, souls with no fixed worth
the righteous charge of the bold.
Sometimes there just isn't a reward
for stepping out of your comfort zone.
the ebb and flow of grace
the high yield of blessing
retarded by the all too quick
think twice—
think at least once—
bravery is the courage to think in precarious moments.

Utter harm of the unnamed
death of the nameless
To be named is to have value
To be named is to be
To be named is to become somebody
To be named is to be granted a destiny

In colour and in deeds you remain common:
a group united by the colour of your shirt and the stupidity of your actions.
Your actions inspire me,
Your actions caution me:
Now I know, Now I'm certain
there is a high cost to being first.
History doesn't celebrate pioneers only thieves and prophets.
Consequences are punishment for the stupid.
gone all too soon
gone not soon enough
you were never meant to last.
Space is a harsh demanding oracle
requiring a legion of sacrifices.
Though you will never be mourned
no memorials will commemorate your sacrifices
you did not perish in vain—
propelling mankind deeper into the realm of space exploration:
there were bound to be bodies in the wake as we traversed away from earth and life.
A wiser course of action?

Adopt a personal Prime Directive
next time: just bring a phaser.

.-. . -..-. - ...

Theology Spectrum

Don't colourize your
Erroneous viewpoints
Like facts when you and I
Know theories are machine age
gods
Instead try to become
Simpler, obtain poverty's
Positive values
Discretion may no longer
Be an option but valid time
Machines are myths

Go bohemian and you shall
Find there are no more logical mysteries
Cliffs will no longer drop before they end
The moon shall not surely follow the Sun

But the stars will always shine

Theologies
And pointing with one
Indignant finger, he declared
The following false:

Time machines
Technology
Pop music
Christmas
…
love

How do you navigate a spiritually bankrupt world?

-.-.-. - -- .- ...

On Stars

People watch fireworks, never the stars
distracted by luminous orbs exploding in intense colours and time
selecting the artificial over the official
too blind to see the Artist's signature.
disenchantment is not being able to identify an artist's art.
and while above as the stars silently go supernova illuminating all the heavens
(fragmented brilliant suicides with no true funeral)
we explore free will with disastrous results
experimentation pushed by curiosity bound by hurt.
Blood
Blood from every suburban home flows out onto
all the wonderfully manicured lawns,
tamed by hearty men freshly restored to civilian status;
veterans who believe in freely receiving respect,
betty crocker wives, white picket fences,
and maybe one-point-five well behaved kids:
who use their suburban bedroom window telescopes to study my Master's goodness.
such free inspiration consistently twinkles, ensuring we will never suffer
from writer's block
that no canvas should remain white—
absent from artful connections and resonating ideas…
eventual images pillaged by Madison Ave. bandits
who saddle beauty with the harsh job of making *me* feel inferior:
modern imagery masquerading as a prostitute to make ends meet
this is *my* punishment for existing in this hustling city awash in neon glow
instead of living on acres of grass and water
operating on high yield land under stars so bright it forces my pathetic life to compete:

fame is not a validation of existence.

With the ease of purpose stars glow strong without thanks each night.
I breathe deep into my lungs pollution "still life"
and know that with each fireworks pop
each dazzling disco display writ on the black sky
each sound, sight and smell will have more
value—more impact more than
I ever will.

..-. .. .-. . . .-- --- .-. -.- ...

20

My Greatest Hits

Looking back reveals how little I have accomplished. I'm embarrassed.
I am not seized with the charge of my destiny;
nor am I fully aware of my moments fleeting…
for I watch tv because I believe tomorrow is guaranteed. I'm foolish.
Procrastination is an option for immortals
and Carpe diem is always on my to do list
but never gets checked off:
instead I languish
want but don't take
dream but never scheme
at this point my malady is so severe
that isolation is the only option. I'm finished.
To dismantle the tv so as to remove the temptation not to think,
unhook the phone choosing rather to communicate with word and written pages.
Isolation breeds prosperity.
My only remaining option—
gladly designing my own prison
taking comfort from new walls;
knowing I've done the right thing.
My gift is too special to waste…
this much; I've convinced myself is true:
now the work to catch up begins.
Wait for me Jesus
 I'm working as fast as I can.

. -- -... .- .-. .-. .- -..

A Warrior Baptized

Out of the strangest passions
and the harshest struggles
come the truest writings of men.
Wars lost and fought
yet in the end every battle costs:
the sacrifice of blood;
mortal man's thinning time
will produce not only an epic
to be spoken of highly
and raved about in smug literary circles
but also mother a man fire-tested
stronger than steel
broken in promise,
vast in truth and talent.
i feel the cause is not worthy—
a better should be for this job
yet truth has no platform.
Wisdom gains no toehold,
no one speaks of her;
ignorance is bred into generations
in this era we call it civility;
mourn the death of common sense by being politically correct.
i see lots do less.
Though my ink and my ideas
will never run dry
I fear the worst.
We've come to this present now.

My fire has died
mark this day
it is black indeed.

..-.-. ..

Blood Stains

 I don't suppose you could know things
not like I do
 I don't suppose you could feel things
not like how I hurt
Suffering so sharp it continues stabbing me
bleeding, staining furniture
priceless objects,
bleeding quietly is rare among "men;"
bleeding well is a lost art
why do you rush to clean blood while you leave me bleeding
let the blood stain
deeply
my ankh
 the one true presence I've left on this rotting world
long after I've gone:
See? I was here.
See? I lived.
See? I felt pain.
DNA proof to silence my existential questions
blood stains
a memory
of the time (yet again) you drew my blood
we cannot change the past but we can forget it I guess
The past imbibes pints of blood—
let my tiny ruby drops
stain a dark rusty marker
I must do this
blood for the future
in case we forget we are human;
in case I forget
memory is selective
blood remains forever

 -... .-.. --- --- -..

After Much Thought,
Here Is The Conclusion I've Reached

If you came to me for wisdom
I'd have to survey my life,
and then I would share the experiences I've had.
I'd list all
the ways I conceded
all the suffering I
brought upon myself—
all the blood—*my blood*—I
shed by impaling myself
on the sharp destruction of my own construction
And in the end, the conclusion we could both come to
is that I don't know
won't know
and may never know
the answer to your question.

..‾. .‾. .. . ‾. ‾..‾‾.

the shape of things to come

the shape of things to come:
I bustle forward
worried about how little space I occupy.
In this brave bold future, how will I know what's mine?
with so much at stake
How do you expect me to act?
How do you expect me to react?
In this brave bold future all I see are mines
ready to denote but will I slip so easily into death's waiting arms?
Ah, funny, I hardly think so.
I will depart, with no luggage
(as you know I had no time to pack)
into the brave bold future

which if I'm to understand from movies—
heck even Star Trek says there's nothing to fear:
I can conquer the creature in the basement.
The dead woman who calls to me rising from the murky hell-coloured depths of my shower
can now be permanently killed.
The inhuman lying in predatory wait for a dangling limb under my bed has run out of nights.
But with all my inner and outer demons slain
covering false victories in blood
What will be left for me to do?
Surely we can find a cure for boredom?
Right?
Right.
Right…

-.-. --- ..- .-. .- --.. .

England

I miss England
 The times
 The history
 The tea
I sit at Toronto intersections waiting for the light
to change
 my heart
 bruised, battered from exploring this cruel world
trying/failing to interpret the actions evil men do
I did not know you could be so mean
shallow understanding
 why it breaks so swiftly
I possess no vocabulary for the things my heart wishes to express
having aged faster than a forest fire
 forced to live industrial
Dreaming luddite organized dreams
Fractured
 Sense
Of Travelling
it all slows down
when
 I
 comebackhome
but that doesn't mean it makes sense)or money(
I will see things
 I want to forget
but I treasure these memories
for they work my personality into something wonderful
Life
 And
 God's Great Design.

 I miss England.

 .-. . -.. .-.. .. --. -

The Edge of 2003

the edge (always) remains the most exciting spot.
altered perspective (always) ushers in fresh insights.
to climb to this point
 did not make my soul any more weary
I remained focused, rarely am I so
 yet easily, forcibly, I ascended to the top
and now my toes point out from the edge
all of me is ready to leap
 into a wild sea
 met by a brightly coloured horizon
but before I can leap
 I pause

This is *one thing* I do not want to rush
happy something close to purity was not shrink wrapped
or offered with a prison-like bar code stamp of corporate approval
 This Is Free
 …Freedom…
and I run back and I run forward
propelled by all the negative energy and positive Love
this last year has brought me
 and I leap first off then up
as if I was superman
 and I so desperately try to capture
all the nature in front of me
 all of the sunset, all of the horizon
but gravity is a powerful idea and I plummet
another sacrifice for the sea which will
swallow me whole
 absorb my entire being
even now as crisp cool waters
encase me like a liquid coffin
i regret not pausing on the edge a moment longer
 learning to be still
 learning how to appreciate

simplicity is too complex for me to grasp
but as i burst through the sea
disrupting the easy daily schedule of waves
and greedily suck at the clean air, filling my lungs deep
expanding my chest—exhilarated
like a baptism
i swim to the shore
knowing however sadly—i have been given
yet another chance
i'm not foolish enough to believe it's my first
living on borrowed time has practically become an
occupation
 but as i clamber onto the beach
the mountain with its sharp cliff edge
beckoning by name and by spirit
 i know i can try again and again
learning from what was sown in the past
knowing each time on the edge
 i face another golden
 ...Opportunity...

 ‾ ‾. ‾

WHY? or The Eternal Question

i seek to discover what i cannot find.
i look for reason in madness.
is there no place higher than mountaintops
where i may go and find answers to my question?
is there no place lower than the depths of the sea
where the dead are buried awaiting the resurrection?
shall i go past hell
or detour through heaven
in hunting for enlightenment?
if i could pass through time i would
crawl in the corner between yesterday and today,
with my right hand gripping a torch
so that i may see,
and my left hand ready and willing
to grasp the answer,
should i find it.
but i suspect the answer lies
not in time or with the hounds of hell.
it cannot be found in the place where
the living say goodbye to the dead.
i feel-fear it can only be found
in the heart of the woman
and worse…the mind that controls the heart.
will i be allowed to trample with my rude
boots and foul torch, through a woman's
spiritual core?
will she give me the grace of an open door
or will she deny me, sending me in
a downward spiral of despair,
my life buckling under the bleak hopelessness
of a quest not worthy to be called history,
leaving me eternally without the answer to my question:
why do women call me cute?

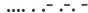

I never fought for you so…why start now?

Bottled Impressions

CONFESSION:
I've never bought red wine.

ADMISSION:
More than anything offered on this vast earth,
I desire to impress you—to win your praise
eventually your heart
but I don't know how to select a wine.
I know all too well—you deserve
a sophisticate
 sharp, distinct class of individual.
We're thriving in the age where it's foolish to believe in Love's lasting power
that Love is some "guided" force
cupid incarnated as a positive destiny for an
encounter between two souls so
desperately lonely their paralyzed mouths never betray their overstocked hearts;
in my simply complicated life, Love remains like red wine
on the shelf
accessible yet untouched, an intellectual mystery
best left to others—I've heard people cut themselves
sharply—so it seems—on the glass when it all breaks apart—others
drink deeply, intimately discovering the sweet value of the elixir
I—I always hesitate before making large purchases
not sure that what I get for my exchange will be
worth it.

DEPRESSION:
It hurts to see red wine on the shelf
accumulating dust instead of adventures;
sometimes I take comfort from what I know
mostly I just live in fear.

.-. . -.. .-- .. -..

Slut (Shortcomings)

Red is seduction.
Your dynamic duo of lipstick and nail polish,
the thin, frilly edge of your crimson bra
defiantly creeping out of your top, enslaving my attention
like a hostage I'm captured and can only hope for freedom.
You carry yourself hot pushing sex on everyone.
Woman talk about you behind your back.
Men dream about you in front of your back.
You glide
making life seem effortless, always evermore about the appearance.
Too special to grapple with what makes a woman authentically beautiful
you do one thing well and you'll always be
famous for that.
 It's no surprise you remain popular
among boys:
 yeah, we talk, gossip, reveal
broken telephone games in the locker room
more fiction than the lies women exchange for sex—
faux warriors with no grit just selfish adolescents who enjoy the easy
I've heard too much, seen so much
felt so much, tasted even more
I don't know what to believe or who to believe.
My experiences don't fit into easily defined
files:
"Stuff I Did With Girls 2007"
"Stuff I Believe About Sex 1996"

No: my thoughts, experiences, fumblings
they're better not brought up.
Show me—
by now your heart must be insulated from pain
I'm next aren't I?
fine: I'll let you seduce me
no matter how temporary
i'd rather give myself to you than to this pain

at least you're warm.

.-.. .. .--. ... - .. -.-. -.-

My Red Box

I still have the box you gave me.
Red like a heart—I often dump
My Fears into it—one of my worst habits.
Sometimes when I think it's empty:
—*Fears rarely last past sunrise*—
Suddenly I find a Love capable of
one last generous act or a
token spoken word of kindness.
Mostly I enjoy the mirror at the bottom
and I wonder if that's why you really gave it to me.
Remind me of the gift I am.
Though it's rare that the box—
red like my heart—remains empty.
I dump a lot into it:
always wishing I had more than one.
It's a bit battered but
well, what can you expect for a
well lived life deep into the 20's?
Once I saw a girl's box—
a much darker, deeper red, dirty almost—
scarred
it hurt to gaze upon it too long and
when she revealed the contents:
practically overflowing
it made me cry—never have I seen
so much hurt in my life.
She pretends the heavy box makes her strong
others may agree but as always I choose truth.
My honesty propels me to disagree.
When she's not looking I steal hurt
from her box and wait for the tide to swallow it whole.
Some of her hurt stains my hands
a permanent dim mark of how little good I do.
Good hardly takes up room in my box—
Not like desire; wishful thinking—aches that produce visions,
what I see when I close my eyes conflicts
with everything I do:
but with my red box press on I must
until I reach That Day—when I stop—
putting things—some good mostly bad—into my box.

Then the celestial show and tell begins:
my box contents on Grand Display.
I'll probably get points for stealing the girl's hurt
but…not much else.
Though by grace
if…
I'm going to change the contents
of my box—red like my heart
I will need strength.
I close my eyes—prayer perhaps—
suddenly procrastination concludes
and an unpleasant task becomes duty.
I open my box—red like my heart
and make room for love—lots of room.
I don't want a small love.
And I make room for hurt—lots of room.
Not my hurt but for those whom I'm destined to encounter.
I know now this is why you gave me this box—red like my heart.
Destiny and duty are the same thing.
In the meantime…I wait for
That Day.

.... . .‾ .‾. ‾

Lipstick

I wear your lipstick smears like smudged tattoos
an enduring exhibit of my sex appeal
yes evidence you find me attractive enough
to slash the distance thriving between us.
You pull me close—*strange as if I don't know what to do*—
and when your body rubs electric against mine
it's a feeling only home has ever given me:
we both know you can feel me, but thankfully by now we're past shy
my arms surround you, fencing you in
(subtle suggestion for utopian vision)
snug, I inhale your luxurious scent
(I'd be foolish not too)
nuzzle your glorious neck
(knowing all too well)
perfect moments last seconds; memories more difficult to extend than night
your lips the sweetest of all known fruits, I ride the rapid currents of your tongue—
past your lipstick covered gates
the physical transaction is completed quickly, spiritually
I never open my eyes when kissing you
—partly praying thanks for your arrival
—partly because I've already began to reminisce
hands through your lavish hair the handshake of all lovers
and the deal is done.
We separate
the ache that preceded you
returns;
Hurry Back Love
Memories
Time
Lipstick smears
Your scent
My life
It's all beginning to fade
despite my efforts against the contrary.

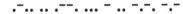

available without struggle

The Coke machine hums blue
but glows red as if
mimicking the embarrassment of this moment:
I've known for a while you were gonna leave me.

I'm hoping you're upset over my collective sins
not on something as trivial as…*this*.
I let you shout—only fair—you suffered a lot being with me
and successfully suppress a smile when you curse.
The University's hallways are empty
Summer abandoned classrooms gently gathering dust.
The only sound—other than your harsh but correct
dismissal—comes from the Coke machine humming blue
directly to the left of us.
I wait for you to finish: one of the rare moments I posses the patience you so longed to see
then nodding I open and close my mouth with the restraint of a monastery monk:
with your last diatribe everything's been said—
we agree on everything but see eye to eye on nothing—
goodbye at this point would—not only be an oxymoron but worse
redundant.

I never fought for you so…why start now?

Silently I watch you go
Silently I let you go
permanently impressed
that from behind you're beautiful—I never cease being amazed at your beauty and
of course:
all the awkwardness it harvested from my lush garden of insecurities.
And when you are finally gone
I hum the blues along with the radiant Coke machine—
without debate I accept its offer having just rejected yours.
One dollar and fifty cents later
I absorb fresh uncorked sweetness;
taking small sad comfort
in the eternal knowledge:
some things I love will always be available without struggle.

.-.. --- ...-. .

Signs

I

decided to follow the advice
of the glowing warm EXIT sign—
packed my bags heavy
gas tank F
clinging tight to a hope which we both know is not mine to claim
I depart from this city of limits

2

a place where I can monologue freely
release my soul with the measured increments of words
harvest inspiration like penny wishes from a mall fountain
I drove and drove and drove and

3

days later *I arrived:*
aided by another bold red sign of instruction:
STOP
I parked my automobile
happy to note my gas tank was E
and decided to survey my new salvation—
and decided to call my new situation:
HOME

4

Now
I begin think talk write see hear...there is much work to do before death comes.

. -- .--. - -.--

The Collateral Damage of
Fried Chicken in America

(Have you heard?)
Fried Chicken outsells poetry in America.
Some stupid colonel—what army was he in?—what was his great war?
armed with 11 herbs and spices
contributes more to our society than a dozen poets.

We all—valiantly if not naively—rail against
the unyielding forces we call history
the demanding pressures we call the future
fearing we will not leave a magnificent mark.
We will die not having improved this busted world;
not having helped to "make things better."
Are you blind?
This is America.

Every dollar you spend is your donation towards change.
You move one of the world's greatest economies forward:
Your dollars are your voice.
Your dollars easily provide CEOs' comfort their billion
dollar corporation will meet its sales targets.
With your dollars you pick one company brand over another:
you are a hunter in this ecological economy where only the loudest survive.
Your dollars are your voice.
Your greatest contribution to our society is how you spend your dollars;
your legacy is how you keep our companies out of the red.
Your dollars reveal your choices not your desires.
Even though the Universal Church sells salvation
we cannot buy peace or redemption;
but—cool—acceptance—originality and even—individuality those are
always for sale but never on sale.
Like unplanted seeds saddled with the potential to bloom
poetry will rot on bookstore shelves:
why impress your Lover
or feed your soul
when you can easily corrupt your stomach with fried chicken.
Poetry can inspire but like all great fires—everything can be extinguished.
Do you need poetry to live?
No but you need to eat.

This means:
not one day passes without reaching for your dollars.
not one day passes without buying something
performing like an honourable citizen not a good Samaritan.
With each passing day eulogies grow shorter;
our lives are not marked by dramatic good deeds
but rather by the bills we amass during a lifetime of splurging and spending.
We never applied for Sainthood opting instead to apply to VISA for the glory of credit.
Hallelujah.
Better to assist a colonel's corporation
than a publisher selling words, languages, ideas and hope.
Until we begin to think we can do no better
when faced with fear
than to order fried chicken
poetry will languish
leaving true warriors uninspired; swords sheathed
and the colonel will have successfully won the war.

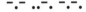

NYC Omen

Once I was a New York City Poet.
accepted for my talent
approved for my contribution:
I fit in, I belonged
those are never the goals but…they ease the pain
banishing crippling artistic fears.
It was in a Borders
close to the Poetry section
shelves stocked with elegant tombs sealing in
hard fought lessons of life and love and loss
which eventually will be cleared for shallow bestsellers.
There…in that section, my eyes constantly roaming
speculating
captured a magnetic poetry display.
Hundreds of fascinating words slapdashed onto a smooth black metallic surface
how often we find chaos frighteningly seductive
clearly:
IT'S TIME TO WORK.
To impose my artistic will on chaos
I never wait for inspiration,
there's just too much work to be done
and not enough poets.
Locked in a fresh fugue I began arranging words
sliding them across the darkness into place
till one poetic line was formed
then another…
bound only by the slim offerings of these words
then another…
I see for the first time how limiting the English language is.
Like the transparency of body language
the best poetry is often unspoken
but today
today was a day for shouting!
As I worked and as I rearranged
a crowd assembled
whispering,
reading the lines as they formed
actually engaging the birthed work
unaware this was not a common bookstore promotion:

I wasn't selling anything
only offering
Only Offering.
Soon the final words slid home.
I stepped back to survey what I'd fashioned
distinct word allegiances that sing only with my voice.
The crowd milling at the base of the escalator
individuals pausing on their way down
to absorb some fresh poetry.
A few began the hard work of unpacking the lines
making the connections that make us intelligent.
Most nodded their approval and slinked away
not here for that:
libraries are for knowledge, bookstores are for comfort.
I was thanked, congratulated and questioned.
My work clearly connected—
I was now a New York City Poet.
I had taken a bite of the Big Apple
and found the taste sweet.
Since then my appetite continues to demand
the place I now call home is no longer enough to quell the hunger.
I'll be leaving soon.
Soon:
I'll be a New York City Poet.

-... .. --. .- .--. .--. .-.. .

Passing Romantics

Re
gretfully
this incredibly romantic moment
is going to elapse without a Lover.
(yes I know I'm not in Love)
The heady combination of balmy night air
my open and warm sense of humour
the frequent play—the food—this walk
your staggering insight into matters profound and mysterious
will all pass away—unable to be bottled
recycled for a later date when Someone Special finally arrives.
It's not that I don't enjoy your company;
your scent; your figure
but this evening—this moment—indeed would be so radically different
if my Love were present.
Even subtle contact—touches—soothe a skin battered by desires
all while harnessing the valid romance of this significant "date"
successfully planting seeds for many more similar times together
as all authentic lovers can confirm.
Romance breeds spontaneity but here with you
I'm armed only with fuzzy suggestions and questions.
I wonder if God knows what He's doing…
letting such a sweet profound romantic moment
pass
when already my existence fraught with pain;
days eclipsed by idle laziness;
longs for a respite;
at least the validation of hope
like a gambler at a slot machine knowing the jackpot is coming closer with every lever tug.
Sigh.
I know: I know.
I know.
"Trust God, son
 and know His plans for romance
are greater than your imagination."

.-.. --- ...- .

Wake Up Tea!

So…
just so you know:
This poem was written in a "downtown café." (ooooooo!)
Yes…
I am one of those pretentious writers
who believes in the transforming power of art.
Who pursues Literature and attempts to
demystify creation as earnestly
as a Christian searches for Truth.
The counter serves a girl with exotic blue hair
and a ring stabbed though her left eyebrow.
A draped cinnamon black couple
with no beginning and no end
occupy a chair so that
even with their clothes on, the marriage
metaphor holds true: they are one.
Across from me a false hippie with a friend whose intelligence
is augmented by a blazer and glasses hold
an educated discussion.
The subject is Toronto Art—
Passionate Discussion…
the type where cookies remain uneaten and tea cools.
The long hair pseudo-hippie espouses
on commerce and art…the evil of it all!
I smile knowing the devil is my muse.
While he and I sip from cups filled
with hot liquids, immodestly priced
provided for us HERE at Starbucks.
The hippie persists …talking about money
 …talking about bucks
Unaware she's beautiful, a woman sits next to me on my Right Side:
While I continue to write proving the
hippie is forever correct about selling out.
I'm sitting alone (my "art" does not count as a persona)
on a Friday night drinking tea paid for
with money not brought in by writing.
Instantly no amount of sugar or honey can make this now bitter
tea sweet and as I leave
the wood and brick store mocks me:

"Thank you for choosing Starbucks."

-..-

Red Alert

My faith has arrived at this critical juncture.
Points of no return have long since faded;
having taken Frost's less travelled road
I have arrived at this present moment:
Poet-prophet writing in a country
riddled with illiteracy.
Our people cannot read nor interpret the signs and wonders.
Though churches can still judge as long as the faithless still generously tithe.
Government exploits citizens who can't read;
manipulated by images of fireside talks,
stats and graphs inaccurately educating the stupid.
Overcrowded schools suffering from deep cuts only
hemorrhage the uneducated.
A system clinging to an outmoded paradigm like a life preserver
when all this time we could stop drowning and board lifeboats.
Rescuing victims from the death grip of poverty:
American ghettos take on an aura of the fabulous
despair painted over by the Almighty Green:
Capitalistic Sheen.

My prayers fall on deaf ears.

Oh
how I "hope"
I hope this final prayer reaches you.
God: you used to speak so loudly in pop culture;
Hear your voice in our music.
Feel your direction in our movies.
Encounter your character in our books.
Now—now you've just gone silent.
I cannot do this work alone.
I won't do this work alone.
Without apologies or even regret
I feebly admit I've made progress a habit.
I need to see change before I believe change is possible:
that's how my faith operates.
Time bends to your will; slow works for you; not me.
How many inches of land have we secured in this holy war?
I must measure in inches, in numbers, in statistics, anything physical
since only you can measure hearts
and hearts change slowly...

"Search me O God, and know my heart/
test me and know my anxious thoughts."
Busted, brought low
with no hope of ever rising
I'm on my knees not to pray
but because I've been defeated.
"It is finished."

Alone I'm just not that strong.
Crushed, a will cannot dream let alone scheme.
My fidelity to you cost me everything.
Regretfully, I have become a modern Job
a sentence I howl in despair
begging for parole.
This is not what I wanted.
This is not what I signed up for.
Where is the abundant life you so glibly promised?
Father, your promises now cut more than they heal.
Where is the abundant life you so glibly promised?
Take what's left.
Take what's left.
For all that's left is my life.

.-. . -.. .- .-.. . . -. -

"Search me…thoughts" from Psalm 139:23

Daniel

1) You are not loved.
2) You are not lovable.
3) You have no worth.
4) You have no claim to hope.
5) You have no access to grace.
6) You are pathetic.
7) You have made a mess of everything.
8) Your only comfort is in her bed.
9) You have no reason to live—take your life.
10) There is no greatness in you.
11) You will never do great things.
12) God does not love you.

NO

Enough—I will not become food for the roaring lion.
Tonight—I am Daniel!
To believe a single lie would make it a toxic fact—
Despair will not claim the throne and have dominion over me:
Dawn Is Coming
And with it new Light
New Light: You'll see.
New Light: I'll see.

<p align="right">⁻..⁻ .. .⁻..</p>

Red Planet/Graceland

On 46th street the winter wind bites my flesh…
corporate garbage piled high litters sidewalks
layers and waves of human and metal traffic jam The City.
All stalled in the ironically named Rush Hour:
car companies promote horsepower and extol raw speed…foolish…
just make sure the seats are comfortable.
We never go where we really want to go.
Hard to believe, following tonight's meeting this way of life,
this delicately complex society
with rules and etiquettes and beliefs
is ending.
Feels so sudden and feels just like right timing.
Dazzling in the night's sky—God's diamonds—
The Red Planet hangs like one tenth of a celestial mobile,
popping my coat's collar in defiance of the ugly wind
it's difficult to understand if the mobs in-stores don't know what's coming or do
and just don't care.
One last purchase, one last product…one last hope.
Every product is a hail mary shot at happiness; shame, most aren't successful.

Now: we should rename Mars Graceland
the future hope of mankind
The chosen few are now going to Graceland.
These are the new disciples
absent is Judas and a leader willing to be a martyr;
every cause no matter how just is soaked in the blood of saints;
broken prayers of the spiritually malnourished.
Every fight, every victory and every setback brings us to this tipping point in history's rule.
Cars collide: torn metal shrieks like a burnt child.
I trudge on; behind me small men settle differences with big fists.
Did we ever progress or were we always just chasing our tails?
How can you measure progress if prophets don't speak up?

Here…I've arrived.
At least that's what I thought this past November.
Pushing up steps, forcing one foot in front of the other
I don't want to be here; I have to be here and do this.
Men never need fear speaking goodbye.
Even though death is scheduled there's much to fear;
a man is only as great and as a big as his courage.
Knowing that I sit down, uncertain how to start, knowing only how to conclude:

Father I've come.
I'm not sure if this is goodbye or if this is later.

Red Rose Satellites

the little boy studies
the satellites tonight
his arm thrust out
closed;
his fist tight
opening;
slowly is his fist
then;
his hand opens wide:
red rose petals fly out
taken by the wind
memories become amnesia

red rose petals drift on the
ocean caress of the north wind
his eyes close and he remembers
summer
Summer which he freely embraced
Summer that's at an end

having exchanged Innocence for Truths

All sales are final.

.-. . -.. .-. ---

Hope—the eternal hobo—never finds comfort in my heart.
These new obligations are helping me believe.
Traditional responsibilities are strengthening my faith.
We need a fresh start;
I need a fresh start.
Hit the reset button.
Try to get it alright.
Try to get it all right.
Redream and rehope.
I'm going to Graceland.

There's calm to the silence I know I won't sense for awhile.
I'm supposed to ask my Father to come with me;
that's why it's called Graceland
but the words stick in my mouth.
I close my eyes; shuffle my hands into my coat's pockets.
Clearly he knows…clearly he understands the position I'm in
why I need him now and what I need from him now.
Neither of us is willing to break the silence.
So much for being men.
I rise, eyes still closed as a wish that wisdom was here; she always knows what to do.
I can't say anything so I do the loudest thing possible:
I turn and leave.
He knows, he must know.
Maybe he doesn't.
Outside on 46th street
the wind's fierce howl mocks my feelings.
My feet hesitate even though they're pointed away from my current destiny:
I can't go back.
I won't go back.
Try to get it alright.
Try to get it all right.
Redream and rehope.
I can't believe I just said that.
Father, I will look for you;
I hope you will be with us on this journey.
I don't want to go alone;
not without you.
I walk down the steps uncertain
is this goodbye or later?
With or without you
I'm going
to Graceland.

—— ·— ·—· ···

Silent Styles of Mannequins

Interrupting the (imposing) bricks forming a great wall
is a window—the transparent eye reveling a well dressed
mannequin;
fashion frozen in post-current style.
(always)
like western gunslingers we face off—our weapons eyes
ageless beauty etched onto plastic
while work leaves my face ruined and riddled with concerned concentrated grooves;
it's not that I want to win *but*:
I yearn to know the peace she yields from being
—*still*—
the joy she grasps
watching an entire frenzied world race by
powered by prosperity, fueled by function
not submitting to the dark desires beckoning participation;
she's calm amidst brand-name flows
(the only one in the store not buying—I deem her unconquerable)
ever since I arrived downtown I'm in a rush.
ever since I arrived downtown I'm in a rut.
Time deals with me harshly but *she* never ages
does time fear her?
Time despises me: I exchange time for money
and that "bargain" makes me a common TGIF clockwatcher.
Another forlorn cog in the market machine;
I have a tie and a briefcase not a soul—
unhinged, my spirit flutters between such and much devious definitions of
Love & Grace & God
but you: you remain
(always)
watching so many souls pass you by
you see the smiles of Love, the scars of love
so many souls pass by you
do you see all people as aches?
affirm the diagnosis; loneliness is our national epidemic
(how long can I suffer silently?)
strange how loneliness afflicts us all so that this common ground means we are not alone.
wish or what that I would be able to see what you see
to taste freedom and be refreshed
to know what truths keep you still
where I to *be still*
imagine the certainties I could harness
to deactivate a brain from this vampiric society

(I don't want to want)
I want to taste an inner peace free from a barcode stamp.
quicklyswiftly
the mannequin and I change places
she doesn't protest
 nobody notices my absence
as the world sprints on.

 ‒... .‒. .. ‒.‒. ‒.‒ ...

US Bombs

I envy modern American bombs
even when passive they remain deadly
caged energy patiently awaiting opportunity:
slick romantic demonic suggesting ability to
usher in a "new world order" and recommence the commerce way of life.
Establishing democracy before establishing hope
when launched—see already so different am I—
they are focused—while I jitter—MTV
vapourized my mental landscape—mugged my aesthetic for all its value.
Sweet sweet bombs rush to their destination
full of power and purpose
powered by purpose
never questioning destiny, rather
altering it like a surgeon rebuilding a knee.
Zen—they slice through air
task so overpowering any luscious temptations are instantly ignored
too distracted to ever be that focused; I remain torn and live dissatisfied,
in a world of Coke and Pepsi, McDonalds and Wendys—there are no choices
only neon powered lusts and fragmented promises of fulfillment—
I crave rest wondering how weak I appear.
I rush all day with no clear destination;
I know exactly what I want; I just don't know how to get there.
Where is the road less taken that will make all the difference for me?
Smart smart bombs hurtling to their destiny
qualm free—not persuaded
by moral arguments or rational thinking;
they have a goal, keeping it locked in sight, never wandering
always patiently waiting
knowing the destination is the end.
An achieved goal only generates more desires.
Zooming closer, the bomb has no second thoughts
no doubt
no sudden lack of self-confidence
no fear
no dwindling courage
This is the sum of its accomplishment.
As adorned with corporate logos as I am
(fashion decorates me like an Indy car)
each one purchased for its ability to whisper success but
really just making me a loud fashionable failure

Closer Closer Closer
until
Target Is Hit
the sound of its purpose is deafening
Absolute
Permanent

History
is
achieved:

Unlike all of the words I have written.

With each launch:
I envy modern American bombs.

The Swift & Brutal Rise of the Creative Class

Jesus Christ.
JFK.
MLK.
So many more.

You think just by killing leaders rebellion dies?

Rebellion doesn't go out of fashion;
it transforms and evolves with the times.
It's always relevant:
It's always popular:
for every culture You create
there will be an equal and opposite counterculture. I promise.
Or did You forget that…
in Your haste up the corporate ladder
to a corner office, a better title—"power"
shedding utopian visions so You can ascend smoothly and quickly without any *dead weight*.
Before doped up acid trips affected Your morale
making You believe You figured it all out.
All You figured out was how to sell out:
You stupid 60's generation made the pet rock a fad!
Oh-but now like the true brood of vipers You are
eagerly and quickly You shed those "beliefs" like snakeskin
stamping out those idyllic pests to go work for Corporate America.
That doesn't stop—or even slow down—rebellion;
only makes us laugh in pointed finger ridicule.
Your mistakes fuel our progress.
And unlike Your hazy attempts—
Your whimsical feeble folk songs
Our focus and attacks are direct.
Without Your permission; in complete disregard for the authority You wretchedly believe is real:
we are already figuring out ways to get
<u>Free</u> internet service…
<u>Free</u> long distance…
<u>Free</u> music…
So much more for free.
Don't you get it yet?
We will take with both hands what we want; when we want.
You attach these paper thin morality and ethics to taking for free;
like cattle branding downloaders as antichrists not as the true prophets they are.
Far better music carry the barcoded mark of the beast lest profits be affected—
suddenly now valiantly defending artists; so noble

when they are the first to be silenced in any and every war.
Especially the wars you organize and campaign.
Truth's power can only be as strong as a society's artists.
you have no claims no © on my future or my work.
you do not design my future.
Our future doesn't come with a Coke and a smile
or some stupid trendy designer outfit.
There is no corporate approved cool in *our future*.
your way of conducting business lumbers like a dying dinosaur.
We have zero sympathy for you; only honest anger:
We rebel because we are kings living in forced poverty;
I am a king not because I have or even lust for power
(as pathetic shallow creatures like you do)
but because I have an identity.
One I've claimed with the same "dirty" hands I use to threaten your fortunes with.
I am a person, a child created by God
to do good if not great works;
you think you could buy us with corner offices and hefty pay raises?
We have a life outside of work; work is secondary to us;
your agendas conflict with our peace.
you don't even realize that do you?
This is what makes me—us—individuals: *we think*.
and it will always be thinking that launches us into trouble.
It means we are no longer blind.
Scales have fallen from our eyes.
Vision always begets visionaries.
No longer satisfied by government approved crumbs
we want to yam meals. Succulent 5 course meals.
And so—from your small-minded perspective—the savage taking begins
rebellion continues
and martyrs—those you feel are too much of a thorn and not a simple quiet citizen rose—
only encourage us in life and in death and in love.
you think we did this before adding up the costs?
History is our greatest mentor;
predictability and arrogance are your greatest downfalls—
your rising and falling are the milestones—the markers—of how our history will be judged.
60s love flatlined in the greediness of the 80s.
Foolishly believing in "flower power"
always your generation and its lust for power of any sort.
Stupid:
rebellion never goes out of fashion.

We remain unsatisfied.
For all the "choices" corporations lead us to believe they offer
there is one they cannot offer because it cannot be
manufactured and sold in a mega-chain-store:
A bright and happy future.
Overcome—it's our prophecy; our destiny.
Justice will prevail.
If we work hard each and everyday.
Together with all of us.
And we will work hard each and everyday.
Just not for you.

.- -. --. . .-.

Sweet Souls Struggles

The restless ghosts of martyrs
haunt my indifference
struggling unsuccessfully to slay my apathy
I just can't do it alone.
Even with the tools of production trickling down
the odds of success are overwhelming.
I live on the same planet as you
I cope with the same problems you encounter
foolishly we believe solutions are universal
hardly: problems are universal.
And you think by having one or even
two good days—in a row no less—is impressive?
When all the rest of my days are lazy and unresponsive
science struggles to extend the 72.5 years of government designated life
but what good is more life if you don't know how to live?
I would rather get all of my work done in 27.3 years
than waste 72.5 and have to face God:
death comes for all of us ready or not
success doesn't prevent death;
only serves to remind how close it is.
Sometimes success isn't the goal.

Crossing into the next life I meet the martyrs
who perished keeping the wolves of injustice at bay.
They question how I carried on the work
extended the legacy of peace and let hope grow as if
planted in each successive generation.
My silence will damn me.
It's certainly not like I didn't have one or even two helpful moments
did some good, eased some suffering,
though not my own; never my own:
honestly: I've multiplied my regrets.
My life nothing but a failed test
dozens of blunt red X marks from where Teacher
saw me go wrong.
My love was lazy so maybe it wasn't real Love.
Now dead
already on earth I am being forgotten like so many other ecological problems,
people busy with sports pages, crossword puzzles and comics.
I am not worthy of the company I keep in heaven.
Send me back to earth to haunt the lazy,
let me be a beacon, an invisible light to those on my lousy path

The past is set in stone.
The present is set in a choppy sea.
The future is set in marble clay.

−··− −−·−·−·−· ···

Flight 23: *Wingspan*

Thank you for June 5 1991

To slice air
tongue out
sailing like a superhero without a cape
past earthbound flash-frozen defenders
was a pitch—not just a dastardly challenge
to gravity for all the times it kept you down:
Everything in this world conspires to keep you down
We—I—must rise
in my bones rattles an undying fire to map the atmosphere,
to make the stars my acquaintances
leap as you did—do
high into an untamed fierce imagination.
The sweet unbuckling of rationality
as you defy the senses,
my mind struggling to comprehend
as in the air you are forward
focused, locked on the prize
inspired—yours is a legacy of inspiration:
the valuable sum of small things adding up,
tiny decisions power over free will—
and as you bring the ball down
as effortless as clouds release rain (but no less complex)
my passions are stirred—I cannot
will not
accept the ordinary.
Courage is knowing the odds—wisdom is defying them
snapping karma over my knee
I graciously reach out for grace:
Starting today…today is my starting line not my finish line,
not 0.1 second more will I accept
these systems of can't and no and not for you
we're sorry, try again, maybe another time, play again, better luck next time
rigorous shackles for petty slaves who should know better;
who should live better.
Yours is a legacy of freedom
of flight: of lungs who have sipped the breath of elevation.

Vertical leaps into worlds we rarely have the courage to dream of
yet our hearts assure us they exist.
Such faith
living on the fly
take me with you
 on your flights
I want to see
 dream
 be heroic
forever flourishing under the shadow of your wingspan
yours is a eulogy of surrender in love.
Yet is the most powerful word in the English language.
Yet is the promise God advertises in every dream I have every night.
All I have to do is one simple thing:
 Jump Man
 Jump

.--- --- .-. -.. .- -.

The Game Changer

We live in the heated glow of our generation's burning bush.
An epidemic we fail to note
on the way to—on the way.
A defenseless nation picked clean under colonial rule
now beleaguered by this AIDS menace
helpless not hopeless
these thick flames demands a soldier's response;
volunteer firemen to heed danger's siren call
pressed into ready service
knowing vision must come before courage.
Fear keeps us rooted like winter-shed trees
like Moses our inaction exposes our hearts.
like Moses we offer excuses not solutions.
Before this burning bush
we stand in righteous and correct judgment:
failing to remember
true love is universal.
So is justice.
There is no us and no them only our collective humanity.
As always, the choice
with every friendship and romance and connection is
Fight or Flight;
we must break the habit of giving up; of letting go so easily.
Each of us are armed with a voice
if not a vocation: we're warriors in need of a war.
Or rather we were warriors—now
passions mired in vice,
negotiating modern life,
high wire balancing acting of the successful
before the death dust becomes apparent.
Eagerly accepting the Lies of Authority
"We're doing all we can."
"as am I," you murmur in adequate scripted response.
Emergencies are never scheduled into blackberries
but there's always time to indulge.
The harsh light of this burning bush
reveals us to be men locked in stupor
hungover from horoscopes, foreign markets and subway sudoku puzzles.

Circumcised by religion to God the Father
castrated by a society of absent fathers
we spend 5 business days trying to impress our earthly father
and a weekend shooing away the guilt from our heavenly father;
nothing we do is good enough; nothing we do matters:
In both realms we're sons who don't measure up
no longer warriors:
we're men only in name never deed.
Instead of busily assembling furniture and weapons
to furnish the fort will we use for this modern battle
we compete with justifications.
Celebrating false milestones in bars;
too inundated to accept this game changer.
Modernity erased all the rules we played by.
The goal is elusive.
Nothing moves more slowly than a human heart attempting to change.
You can't desire change if you don't enjoy the process.
We cannot keep score
for at stake are human lives—
—our humanity—
lives are stories categorized by statistics.
This is the only championship match
Game 7.
Already decadent rockstars fight on ahead
cashing in on the currency of celebrity
and I've had enough.
No More.
I engineer my own escape from this opulent prison of society:
abandoning despair and now with freshly freed hands
I grasp onto my armour.
I RSVP the burning bush invitation.
I want to be there
On the front lines
In the final moments
As the game clock winds down
I am stepping forward
Hands open
 I will marshal my courage
And take that final shot.

Lord Guide My Hand
May My Aim Be True.

.- .. -.. ...

Atlantis Acceptance

I gaze with beady bloodshot eyes, drowning in tears
at the spot where your taillights last were for at least 15 minutes.
And I have neither gotten famous
or moved an inch.
Barely breathing.
Desperately wanting to escape this
inner city malaise—fractured relationships
people say they want love but then only offer sex
jump into my car and drive—
in this drab city my mind has already departed
seeking not Sunshine or bikini clad companions
only want peace and freedom to enjoy it.
This time *successfully* driving past nefarious temptations
"Good salary." "Good house." "Good wife."
The envious call these enticements security
my thesaurus calls them traps.
Still: God only tempts me as much as I can handle.
Must flee or die slowly, surely, completely like a chain smoker
Drive Drive Drive Drive
It takes too much effort to be somebody when all you want to be is nobody:
I envy paint's ability to control the tempo of the room while still being invisible.
Take—strip down my new age identities, log ins, passwords, profiles
no longer a customer, 9 digit id-number, a demographic, a mark,
is individuality achievable in a mass market age?
I can't reject every lie I must believe some.
My clothing promotes labels not wisdom,
my speech too slang-disorderly to express eloquence like grace:
Drive Drive Drive Drive
like a modern CEO beholden to shareholders until I hit water
—land comes to an end—
and sea spreads before me
like God's big open fist.
Secretly passionately
Atlantis lives below the murky waves
a superior life there than here.
Better is sown deep into all of our DNAs:
I regret rejecting the call until now.
Inhaling deeply smell calm—the stabilities it breeds.
Exhaling letting impurities out—the agonies enforced
by living in a personality killing world.
For all the things modernity blesses us with
absent is the chimney sweeper for my soul.

Encased in a coffin black
I've run out of patience waiting for the angel with the bright key.
Hearing the invitation to return to Atlantis
I plunge headlong into a sea of history
sinking to a sweetness so sweet
I: —
I know where peace lives
And its address is not mine.
Atlantis I've come.
Atlantis I want better.

⎯ .⎯ .. .⎯.. .⎯.. .. ⎯⎯. ⎯ ...

Slow Motion

I relish slow motion action.
Perhaps because I was born long after the talkies were—
and yet sadly
in life:
while movies allow for accessible time travelling and slow motion
life affords few comforts
for those saddled with regrets.
worse, with no way to go back
to what was once sweet:
Memories frame all perception, creating a startling lack of revelation—
Truly Aware: I now know how gentle
— with such sweet grace as only the Good Lord allows—
your rhythms are as you sweep up your hair.
what once bordered the peaceful beauty of your youthful face
now remains hidden like an auburn mystery:
locked back in restraint
no longer able to be stroked behind your ears
or caressed by courageous winds without self-control.
But: what I treasure most is the stubborn strands
dangling in rebellious refusal
extending down the length of your soft, smooth face
subtly hiding your left eye under shadow.
It was that precise moment your beauty
became more valuable and fully worthy to be celebrated
but when the rebellion was crushed and all hair was put in its rightful place
it was over.
And I left without speaking a word:
It was over.
I knew that I could not have what I wanted
Not how I wanted.

So I have since learned to do without.

._. . _.. _ _.. ...

River of Speed {an ode to Wally West}

For Mark Waid

Becoming the greatest was the slowest thing you ever did.

Are you (like me) always on the run never feeling like you've arrived?
Hunger, lack of satisfaction are what burn inside me like a raw cancer,
you (like me) were saddled with potential, power and now position.
Inheriting a mantel from the noble sacrifice of Barry Allen
at least your mentor perished after setting the standard—
I must face my father each day; neither of us wanting to admit
for all of his noble sacrifices I am a failure.
Time, time and opportunity
let me grow, let me flourish
without the pressure of clocks:
teachers back away
I won't be able to succeed in the designated time.
That and well…I—
I want to know it's ok to give up {sometimes}
to stop fighting to somehow subdue my moral imagination
cease the evangelical proposition that resounds in every breath
just once let it be easy.
Must everything of value be fought for?
This doesn't make me a failure
it only makes me great {eventually}.
Trust me, trust my talent
the slow sweet ripening of a harvest of ideas
is the harvest my parents recognize only as proof
the restorative destiny of my fecundity is validity of life
today though all I have are seeds not produce.
You understand right?
You inherited a mantel that almost crushed you.
Nothing is more entangling than legacy and legends,
if that didn't finish you off a bevy of villains were always willing:
none so great and powerful as yourself.
The hardest obstacle to overcome is yourself—
root out entrenched dreams rotting in despair
I'll never be a doctor or a lawyer
comfort is knowing what I will become.
Your sacrifices have been duly noted
duly appreciated, catalogued
I live and breathe them each day like a son of immigrant parents.
And if I never say thanks it is because
it is so inadequate.

Time passes by on a river of speed
Sunrise to Sunset—the power and beauty
of God ignored by a society all too blind.
Do you (like me) want to stop running?
I want to work West
know I've arrived physically if not emotionally
I want to rest.
Learn to be still—be present in the moment like a method actor.
Time hastens death's appointment
let my hope be dictated not by circumstances
but by something far greater than the speed force.
Thank you for your example; for being there
And knowing when to run on.

<div style="text-align:center">

Together we run on
Towards the fresh dawn

</div>

‑‑. .‑.. .‑

Scarlett Fever

I (The Cheeze)
Baby take my temperature I can feel the heat starting to rise!
My heart starting to pump & thump—flowing
your hair could light up the night sky in the desert.
Your eyes harder than steel more inviting than a friendly hostess.
While your crossbow fires an arrow
piercing the marrow of my heart—more
potent and more accurate than Cupid on Valentine's Day.
You may not be real but to me you're real
as a fantasy you take my imagination captive
holding it for the ransom of love;
and all the peace love instantly ushers in.
Take my hand; take my life and my last name:
you're a solider—need a fight?
Fight for me—fight with me (you know what I mean…)
become a permanent part of imagined me
help me help myself;
I want to become—not alone—somebody.

II (The Impact)
Even now the women I'm drawn to
are so easily divided into Scarlett and Lady Jaye types.
Always forcing me to pick sides to do what is right:
balance is unattainable so I don't even bother.
Oscillating between wants and needs, rights and responsibilities
to be a man—which Scarlett has with Duke:
It takes a man to be a man.

III (The Summary)
Encountering such a fierce and lethal beauty
knowing for certain this standard is attainable—
shatters any preconceived ideas I have about the typical beauty of women;
leaving me with tattered assumptions
hardly anything for me to wear on dates.
Instantly I recognize
in response to your life, to the choices you have made

to live the life you want to live
you require a man:
A Warrior.
Wars can never be noble or just—
but warriors can.
Strong and noble: I want to be your Duke.
The strong leader, a braveheart of men:
Let me be your man.
Let me be strong, pull down your defenses.
Let my love shatter your strongholds.
I'm not trying to be your everything
I can't (and won't) promise you the moon (as it's not mine to give) —
I just want to be your man—
with everything that entails.

... ‾.‾. .‾ .‾. .‾.. . ‾ ‾

Twip

It's a sound I've never heard
yet instantly it floods me with comfort
the deep warmth of home like when dad leaves the porch light on.
Twip is the sound Spider-Man makes
when spinning a web—in other words
when he's being Spider-Man
and not being Peter Parker.

I am a Peter Parker.
I am surrounded with Peter Parkers.
timid, fearful and afraid
awash in their own loneliness.
Fear rules us more harshly than any evil dictator.
It's become paramount
to build niches—in this world you must find your place not yourself.
But it's become almost impossible
to build a niche.
Can any of us really claim surprise when rejection comes?
Like sunrises, like death, like rain
for every child born only rejection is promised.
The world may not know what it wants
but it doesn't want what you offer.
Can't live in our society for a couple of decades without
figuring out the absolutes—
with women: "take it on the chin."
at work: "roll with the punches."
in church: "go on a wing and a prayer."
Pain is another absolute.
I can't find the words
or draw the images to share
the depth of my suffering.
The consistent sharp sting of an ache
producing character but often not hope.
certainly not love.
My pain is personal; my plight is universal.
Peter Parker is never accepted.
Though gifted his voice was marginalized.
Undaunted, sidestepping the quicksand of despair
he pressed on; he became somebody; he is somebody.
Perhaps the message's medium should be altered.
Power lies in discerning the right mask:

"Man is least himself when he talks in his own person.
Give him a mask and he will tell you the truth."
Twip.
Peter Parker didn't become great;
he became Spider-Man.
If that's possible
then all of us Peter Parkers
can become Spider-Men.
Twip is hope.

... .--. .. -.. . .-. -....- -- .- -.

"Man…truth," quote by Oscar Wilde from Intentions (1891)

US Tide

Purity can be purchased!
Stains on my teeth can be removed:
I can be white again.
Efficient machines wash my car
It can be white again.
Nothing can mark or disfigure my clothes
Evicting stains like a ruthless sheriff, I am
—*at last*—in control:
Now is the time to be white.
Behold the awesome power of purity.
Purity is at hand for all of my possessions
With churches only offering me Starbucks
I will not despair; not in this great country
not in this great moment:
It's American to say:
"There's more fish in the sea."
To see a crisis as an opportunity
she's gone now but I shall not weep.
It's American to say:
"Every dark cloud has a silver lining."
To recognize a fortune is ready to be assembled
when opportunity knocks.
It's American to say:
"Get back on my feet."
To not stay down under a gathering of black clouds.
It's American to harvest
incorporating a mining operation in the sky
and harnessing the silver from those dark clouds
not because it is easy but *because it is hard.*
With so many dark clouds across America
I'll be in rich in no time.
It's American to be rich.
To exploit advantages, if not the people:
it'll all work out as
It's American to be optimistic.
The sun will come out tomorrow.
But with new light comes the revelation of my sins&stains

It's American to be clean and maintain
especially when involved in dirty politics.
I try to be white and bright
It may be American to believe that
I am alone in endeavours
it's certainly American to believe that everything works out for those whom God Loves:

 My flag is raised
 My flag is clean
 My country is not

Vexillology

I. America
With this fabric you signal courage.
With this fabric you identify pride.
With this fabric you symbolize freedom.

With hand over heart you pledge allegiance to a flag: to a nation.
Feel your heart beat new life as you intake the tricolors;
all the sacrifices and struggles brought us to this profound present moment:
living in fear, stock markets dictating emotions,
citizens rationing hope since we are not assured of having a steady diet.
This is how far we've come since 1865.
Red White and Blue achieved independence through a deadly civil war;
a wanton bloodbath birthing great leaders and radical traitors alike.
Today we live in the cruel imperial shadow of the 14th Amendment
having bitterly accepted slavery's end
while still holding steadfast to the ambitions of racism.
This is not the freedom we were promised.
This is not the freedom we deserve.
We cannot go forward until we finish paying reparations.

II. Germany
With this fabric you signal sorrow.
With this fabric you identify Nazis.
With this fabric you symbolize hate.

Crushed: hopeless people are dangerous.
We should have done more; we should have reached out;
we did nothing.
So a philosophy of hate and despair formed;
variations on the same common themes:
always about the us and them. Always.
Accepted and adapted by the hopeless, empowered by Nazi salute
global aggressions soon followed.
The despot was defeated; tyranny crushed.
Victory no matter how hollow is still…victory.
Remember? "The end of the war to end all wars."
Just another historical fallacy and primitive philosophy
humans endow war with; to give it lustre and an immoral PR spin.
We cannot go forward until we let the past go.

III. Russia
With this fabric you signal power.
With this fabric you identify Communism.
With this fabric you symbolize history.

Better dead than red.
Indeed: tired of burying dead youth—they fashioned a cold war;
battling with slogans, unleashing the raw power of Madison Ave.
Expecting us to continue modern suburban life undisturbed
as if we were not all living at gunpoint lest the doomsday clock struck,
offering us only the protective shelter of a meagre school desk.
While both our citizens went hungry and poverty's foothold grew stronger
we ran a space race conquering a realm humans were never designed for.
Communism was the great grand experiment that failed its own citizens;
yet Capitalism doesn't always feel that righteous. At least we won.
Now we can shop till we drop.
We cannot go forward until we make peace.

IV. China
With this fabric you signal expansion.
With this fabric you identify competition.
With this fabric you symbolize New Economy.

An ancient civilization with claims on the future,
this lonely superpower is impatiently waiting for the US to decline;
so that it can successfully transition into the dominate superpower.
Emboldened to march on America through vicious cyber attacks;
black markets being the most free markets.
Now one billion strong they are the New Economy;
the government struggling to withstand the internal demands
of a flourishing middle class only marking time until these people
are vitalized by human rights and responsibilities.
We cannot go forward until we cooperate.

V. Canada
With this fabric you signal next.
With this fabric you identify benevolence.
With this fabric you symbolize change.

Living above America are citizens
with no national identity often eagerly embracing
the Red White and Blue philosophy smuggled in through movies and commercials.
It's easy to be somebody else harder to just be yourself.
A double minded country struggling to remain neutral:
we cannot choose peace by being neutral;
we cannot promote peace by being benign.
In desperate need of a leader: an uncompromising revolutionary with
a deep thirst for justice and liberal future designs
because we can be the future.
To get up, stand up and step into the light:
we have choices to make and so far
we're making the wrong ones.
We cannot go forward until we change.

..-. .-.. .- --. ...

Partial Liberation

When I heard about the fire in Scarborough
I knew what had to be done.
In my basement between dark and deep I rescue Love Letters.
Paper time machines whose touch instantly take me back.
Remember those Japan days?
God: I learned so much—felt so much
everything was real,
it actually felt possible to live in the moment.
Your love was brand new glasses
I could see—just not our world—so many things clearly
almost as if for the first time.
So of course it was too good to be true.
The bundle of Love Letters held together with red ribbon and
sticky memories of a time that feels heavier than forever.
Envelopes addressed to a home I no longer live in…
may not even be there now with all of our progress;
papers—yellowing with age:
does love age or is it possible to keep it fresh?
Fighting temptation but as always too weak to win
I free a Love Letter from the stack.
The date tells me it's near the end…
oh God: *hindsight.*
Weren't all the clues in front of me?
What do I see now looking back I couldn't see coming?
You write, alternating between silly and serious
…did I ever tell you how much I adored that?
In your absence all I can do is appreciate your quirks.
Your ability to make me laugh, make me think was an incredible gift.
Seems a shame to let this all go now…
No!
It all has to go.
Nothing stays.
Quickly, before losing more resolve
I clamber out of the dark basement into the light.
I feel irrational:
 like I'm in love again.
I don't remember getting to the car.
I don't remember getting into the car.
I don't remember driving…
 but all my determination has brought me here.

Police, firemen trying to save
the old neighbourhood from dying.
"Our house"—we always said it was *our* house on long walks through these streets—
is consumed by flames.
Part of me doesn't want it to go
then again who promised me it would always be here?
Only lovers talk about time in terms of forever.
I've come this far: I will not turn back.
Moving closer to the house;
cops don't notice me
firemen busy working at putting fire out of business.
My heart heavy but certain
I tear the ribbon off the Love Letters.
The heat is intense: I don't step back.
One by one I toss the Love Letters into the flames
destroying dreams and memories.
This house must burn if it couldn't be "our" home.
These Love Letters must go if this couldn't be our love.
My eyes catch words—phrases, beliefs and more as the Love Letters curl in the fire.
"…got another funny story about my sister…"
"That's why Japan is so beautiful…"
"I miss your smell."
"…when I get back…"
All of our time—the quick easing of pain
the dissipation of loneliness—jokes all well documented now burn.
"I do see God in this mess…"
"…sleep with you…"
Why does it all burn so easily?
Do you think about me?
Your face haunts my mind.
The part of me: the part of me that doesn't focus on
getting my work done or paying bills;
the part of me that remembers the possibility of this home.
and what growing up in a neighbourhood like this was like;
why it was so ideal for us to come back (after always after)
and start a new life together
in this house.
"At night…"
"…last night…"
My heart has many contradictions
conflicts make decision making hard
which is why after all the Love Letters have burned
all I have left is a tape of your voice.
God: I adore the way you tell stories.

Even when the event happened to us
you had a way of describing the tale
like an epic opera complete with humour and suspense.
God: you had a way; an energy.
The tape goes into the fire
my heart moans and I don't know if
it's healing or losing baggage or
"Lady, you don't belong here."
The fireman is right.
He's not the only one putting out fires tonight:
we both have work to do.
I walk away and I'm scared to look back.
I don't want to turn into salt or stone or
I look back anyways.
Bits of burned Love Letters drift up
like kites without an owner.
I never had trouble forgiving you.
I never had trouble loving you.
Never had…
 trouble letting you go.
Leaping tongues of flame
make dancing shadows in the dark night
but I can see enough.
The part that thinks about you.
The part that thinks about this place as our home
is getting smaller.
It has to.
 My heart has no more room for pain,
better to nurture the part of me that pays the bills
the part of me that works long and hard;
keep the irrationality of love at bay.
Even if all love ever did was provide stability
I'll find another way to be stable to be healthy.
I go home.
 Alone and without you.
The home we always wanted, the life we always said we'd built
is now finally going to be put to rest.
God: you had such a way.
Now that I am free
maybe now: I can experience freedom.

..‾.‾..

(closed fist)
Not shrewd with my craft
Your damn silence isn't my fate
Apathy isn't love

(open hand)
You are deeply loved
Treasured beyond all value
Grace: is always here

Tip of the Hat

Ok I'll try to get my acceptance speech all out before I get drowned out by the music.

Right so of course sticking with the script first I must thank God. He gets Psalm 19:14. It's been a fascinating ride to get to this point. Sorry if I insisted on always driving and you got relegated to the sidecar.

First thanks also go to you: Righteous Reader. Writing has no worth unless it gets out there, for it to be successful it must connect. I hope *Red Letter Nights* gave you something of value for your long journey. At the least may you be inspired to go out and achieve your own projects. In a world of mediocrity we can always use better, we can certainly use good so never be shy in using your voice to speak up.

yo@sammyyounan.com to share any thoughts, insights or whatever keeps you up at night.

The J-Crew call out!

Thank you *Dustin Ashes* for your editing bravado and the style you brought to these works. These poems are better for having met you.

Thank you *Jai Johnson* for your staggering design and the graphic cleverness you brought to this book. Your touch meant this book went from grungy sweatpants to a velour suit. That's Money. Jai Johnson is a designer, director and creative mercenary working in every medium that he can get his hands on. You can catch some of his creative endeavours at *electriccurry.com*.

Thank you *Jigar Talati* for the photography. Your keen eye, sense of play and approach meant being a model, if only for one day, was intoxicating.

Thank you *Lenore Langs* for Wayzgoose and the opportunity to present my works, you were a gift. Every artist needs constant encouragement yours was a powerful message.

Thank you to DC and the staff at S'up Cuz I know I wasn't always there. Hopefully the work did not suffer.

Thank you to my family here and abroad. Over the years you've said many things about my gifts but you've never said no. That means a lot: single tear, high five, group hug.

Please Support The following:

Kids With Cameras >> Cairo

www.kids-with-cameras.org/cairo

Urban Promise >> Camden, NJ & Scarborough, ON

www.urbanpromiseusa.org

Amnesty International

www.amnesty.org

Oh and remember: never stub out your cigars. Rather gracefully let them extinguish, silently, gently, completely. You know when it's the end.